Paul Klee

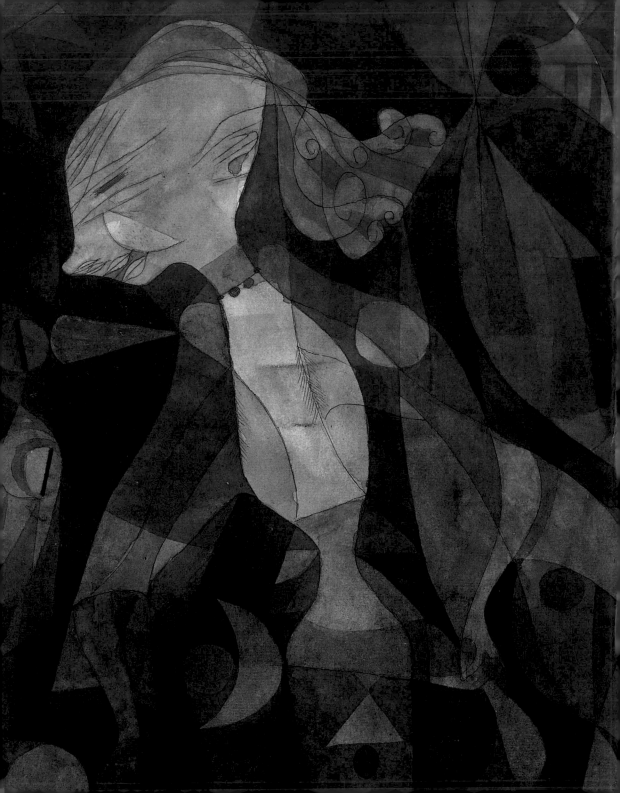

Paul Klee

Flavia Frigeri

Tate Introductions
Tate Publishing

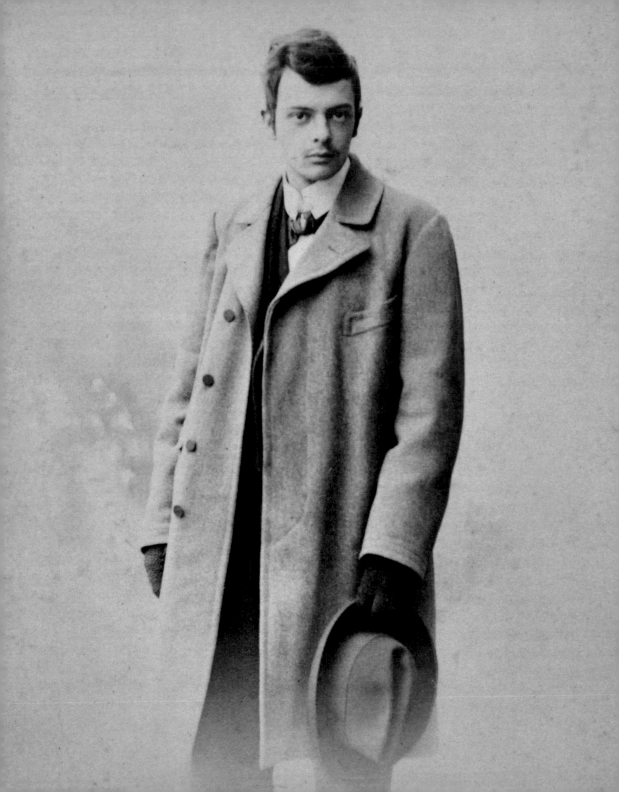

Paul Klee

'The first act of movement (line) takes us far beyond the dead point. After a short while we stop to get our breath (interrupted line or, if we stop several times, an articulated line). And now a glance back to see how far we have come (countermovement). We consider the road in this direction and in that (bundles of lines). A river is in the way, we use a boat (wavy motion).'[1]

With these words Paul Klee expressed his 'Creative Credo', a tale of navigation through the realm of lines. Abstraction is here articulated through a narrative journey. Line, interrupted, wavy or bundled up, is in the artist's mind indistinguishable from the story it is aiming to tell, and it is in this very relation between trace and narration that the crux of Klee's art lies. Embracing both abstraction and figuration, Klee's work draws together extreme reduction and flamboyant figuration, proving that the two are not mutually exclusive but feed off each other. 'A sailor of marvellous boats', Paul Klee navigated life through the stormy oceans of abstraction and figuration during his sixty-year journey.[2]

Early life in Bern

Paul Klee was born on 18 December 1879 at Münchenbuchsee, near Bern, to Hans and Ida Marie Frick Klee. His father was a German music teacher, who taught at the Hofwil Gymnasium teachers' training college from 1880 until his retirement in 1931, and his mother was a Swiss trained singer from Basel (fig.1).[3]

Between 1886 and 1898 Klee attended the Primarschule, the Progymnasium and the Literarschule in Bern. During this time Klee nourished both his artistic and musical talents. A talented violinist, Klee played with the Bernese Music Society in its subscription concerts. Throughout this period, he remained committed to his artistic development, and filled nine sketchbooks with drawings

between 1892 and 1898. Most of Klee's early drawings were landscape views. His father Hans admired these but maintained a sceptical attitude towards his son's artistic commitments. In his diary Klee commented: 'Then I began to consider myself a landscapist and cursed humanism. I would gladly have left school before the next to the last year, but my parents' wishes prevented it. I now feel like a martyr. Only what was forbidden pleased me. Drawings and writing.'[4]

A draughtsman in the making

In 1898, with the end of schooling in sight, Klee was faced with the difficult decision of choosing between a career in music or the visual arts. Torn between these two, he chose the latter and the independence from his parents offered by art. Looking back on this choice he claimed: 'at first it was less the art itself than the prospect of being far away as soon as possible, out of the country somewhere where things were bigger, more interesting, more exciting. Only much later did I realize the instinctive rightness of that decision.'[5]

In October 1898, he left his native Switzerland and moved to Munich. Klee was rejected from the Munich Academy for what were judged his poor figurative drawing skills. Instead, he enrolled in the painter Heinrich Knirr's private drawing school. The student life of the next two years offered Klee essential artistic training as well as plenty of opportunities for entertainment, including balls, theatrical performances and concerts. At a musical soiree the following year, he met his future wife, the pianist Karoline 'Lily' Stumpf. Described in his diaries as the feminine ideal he had longed for, Lily gave a new vigour to Klee's artistic ambitions. Notwithstanding his devotion to Lily, Klee had a brief affair with a young girl, who bore him a son, although the child died shortly after his birth.

Two years after his arrival in Munich, Klee enrolled in Franz von Stuck's class at the Academy. By this stage a confident draughtsman, Klee wanted to improve his technique in coloration. Von Stuck's teachings, however, proved unsatisfactory, as Klee later recalled: 'To be a student of Stuck … sounded good. In reality, however, it was not half as splendid.'[6] Such was the disappointment that only a few months later Klee abandoned von Stuck's class and set off with his sculptor and friend Hermann Haller on a six-month 'grand tour' of Italy (fig.2). Before, leaving he secretly became engaged to Lily.

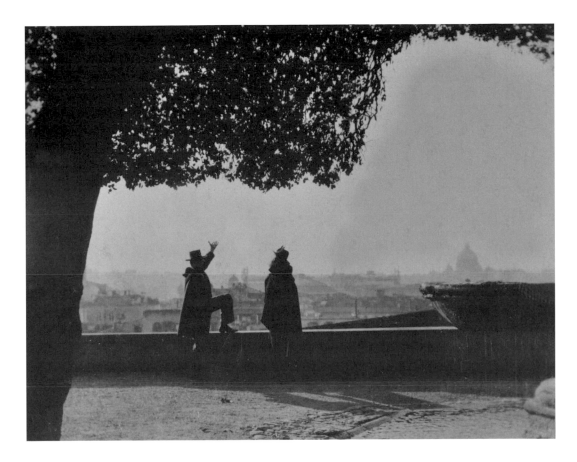

2. Paul Klee and Herman
Haller in Rome, 1902
Zentrum Paul Klee, Bern

In Italy Klee visited churches, museums and ancient ruins, as
well as Italian opera houses. Both amazed and overwhelmed by
antique sculpture and Renaissance painting, the artist experienced
them in terms of a sense of personal and epochal defeat. Carrying
this disappointment with him, Klee returned to Bern in May 1902,
remaining there until 1906. At this time he embarked on an intensive
self-imposed artistic education, including anatomy courses, evening
sketching classes and nude drawing. The most striking results of this
period are the *Inventions*, described by Klee as his 'first usable opus'
(fig.17).[7] A group of satirical etchings, they were publicly exhibited at
the Munich Secession in 1906. This same year, aged twenty-seven,
Klee married Lily Stumpf in Bern on 15 September (fig.3). A month
later, the newlyweds moved to Munich.

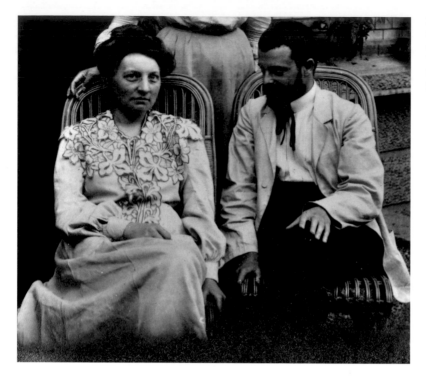

3. Lily and Paul Klee
after their civil wedding
ceremony, Bern,
15 September 1906
Klee-Nachlassverwaltung,
Bern

Munich: Artistic beginnings

Since leaving Munich six years earlier Klee had committed
himself to an arduous process of self-education. The return to the
Bavarian city signalled the opportunity to display the fruits of his
labour. These, however, did not receive the enthusiasm Klee had
expected. His satirical sketches for magazines such as the popular
Simplicissimus were rejected and Klee relied on Lily to provide for
the couple by giving piano lessons. With the birth of their only child
Felix on 30 November 1907, Klee assumed full responsibility for
his son's wellbeing as well as taking care of the household (fig.4).
Meanwhile, in the kitchen of their small three-room apartment in
Schwabing (Munich's artists' quarter) Klee continued to experiment
with light and dark forms in charcoal drawings and watercolours.
Colour, a persistent technical challenge for Klee, does not appear in
his works until the summer of 1910, when he introduced a subdued
palette in his watercolours (fig.18).

It was in 1910 that Klee had his first solo exhibition. Showing over fifty works from the last three years, the exhibition opened in August at the Kunstmuseum Bern and later travelled to Zurich, Winterthur and Basel. Rounding up this exciting year for Klee was the encounter with fellow artist Alfred Kubin. An event of seemingly minor importance, it filled Klee with unsurpassed joy, as he felt he had finally gained access to avant-garde circles. Another sign of his increasing self-assurance came in February 1911, when Klee established an oeuvre catalogue of his past and present works, a system he maintained until his death.

No longer an isolated figure, Klee became one of the founding members of the young artist's group SEMA 1911, to which Kubin also belonged. His attempts to cultivate additional contacts amongst artists ensued and through friend and painter Louis Moilliet he made the acquaintance of August Macke and Wassily Kandinsky. Attributing great significance to the encounter with the latter, Klee

4. Felix Klee
Zentrum Paul Klee, Bern

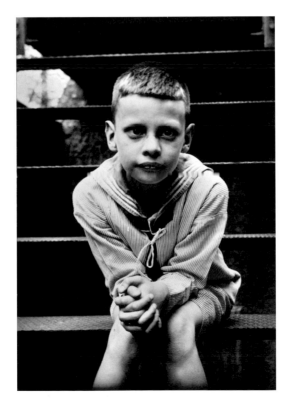

stated: 'Kandinsky wants to organize a new society of artists. Personal acquaintance has given me a somewhat deeper confidence in him. He is somebody and has an exceptionally fine, clear mind. We met for the first time in a café in town … Then, on the trolley that was taking us home, we agreed to meet more often. Then, in the course of the winter, I joined his 'Blaue Reiter'.[8]

A Blue Rider

The Blaue Reiter (Blue Rider), a loose affiliation of artists rather than a movement, was the brainchild of Kandinsky and Franz Marc (fig.5). Kandinsky's belief in a spiritual essence underlying the arts underpinned the group's standpoint. Klee had attended the Blaue Reiter's first exhibition at the Thannhauser Gallery in Munich in December 1911, and joined the group shortly after. At first Klee played a marginal role in the Blaue Reiter circle but was soon able to establish himself as a respected draughtsman. He contributed seventeen

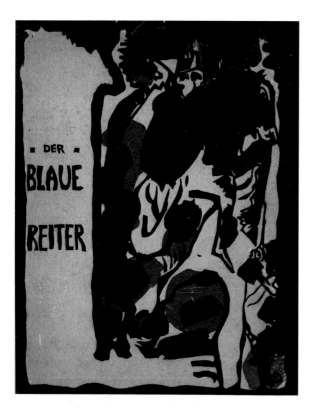

5. Wassily Kandinsky and Franz Marc (eds.) *Der Blaue Reiter* almanac, 1912
Zentrum Paul Klee, Bern

drawings to the second Blaue Reiter exhibition at Hans Goltz's bookshop in February 1912, as well as an illustration to the first and only *Blaue Reiter Almanac* (also from 1912).

The growing prestige amongst his peers, together with the opportunity to meet artists of his generation and his increasing involvement in exhibitions overcame Klee's natural resistance to groups and affiliations. Having worked in relative isolation throughout is career, Klee had developed an image of independence that freed him from any linguistic ties. This individualistic stance has led Klee's biographers to emphasise the uniqueness of his powerful personal language. The affiliation with the Blaue Reiter remains one of the few occasions on which Klee took part in an organised group.

Enthused by the renewed visual language of the avant-garde, of which he now felt part, Klee spent two weeks with his wife in Paris in April 1912. There he visited galleries and private collections. It was the cubist explorations of Braque and Picasso, though, that exerted a special allure. Fascinated by their groundbreaking approach to the depiction of space and objects, Klee remained sceptical of the extreme reduction that this entailed. Suspicious of the cubist erasure of discernible representational motifs, Klee felt more affinity for Robert Delaunay's theory of simultaneity, which through colour contrasts and harmonies produced simultaneous effects in the eye of the viewer. After their meeting in Paris, Klee went on to translate into German Delaunay's treatise on light, *La Lumière*. This was published in the January 1913 issue of *Der Sturm*, an avant-garde magazine produced by the gallery of the same name, run by Berlin art dealer Herwarth Walden.

'Colour and I are one. I am a painter:' The Tunisian breakthrough
In April 1914 Klee spent two weeks in Tunisia with Macke and Moilliet (fig.6). This brief yet much-fabled experience would have an impact on the rest of his career. The warm and limpid Tunisian light in fact opened the door to the realm of colour, with which Klee had struggled until then. In his diary he recorded this fortuitous encounter: 'Colour possesses me. I don't have to pursue it. It will possess me always, I know it. That is the meaning of this happy hour: Colour and I are one. I am a painter.'[9] The quasi-mystical overtone of this entry conveys the enthusiasm Klee experienced in having finally mastered all the

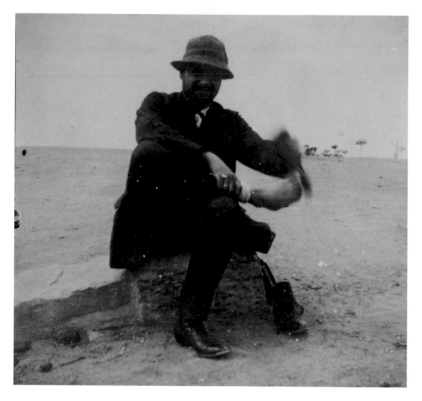

6. Paul Klee on the beach
at Saint-Germain, Tunisia,
1914, from August
Macke's photo album
LWL – Landesmuseum
fur Kunst und
Kulturgeschichte, Münster

techniques of a true painter. Based on a principle of contrasting
rhythmical coloured patches, the watercolours he made on site
convey the effervescence of this transformation (fig.20). Upon his
return from Tunisia Klee exhibited eight of his Tunisian watercolours in
the first exhibition of the New Munich Secession (30 May – 1 October),
of which he was also a founding member.

World War I

The outbreak of World War I in August 1914 abruptly disrupted Klee's
artistic circle. Marc and Macke were drafted into the army in the
autumn, while Kandinsky escaped to Switzerland. Klee maintained
a strikingly apolitical stance, declaring: 'I have long had this war
inside of me. This is why, interiorly, it means nothing to me.'[10] He was
nonetheless deeply affected by Macke's death in late September 1914.

The works from this period visually counter the ideology of war.
Klee relinquishes figurative motifs – too evocative of current political

affairs – and seeks refuge in the detachedness offered by abstraction. In his words: 'The more horrible this world (as today, for instance), the more abstract our art.'[11] In particular, he adopts the rational lines of architecture as a pictorial principle, exemplified by *Landscape with Flags* 1915 (fig.21).

In March 1916, a few weeks after Franz Marc's death in the Battle of Verdun, Klee was drafted into the German Army. Spared from the front, Klee undertook mostly clerical tasks. Stationed at Schleissheim (near Munich) he painted and repaired numbers and signs on airplanes, and in Gersthofen (near Augsburg) the following year he worked in the paymaster's office. Finding time to paint and draw, he turned away from reality by seeking refuge in a fantastical world inhabited by enchanted creatures and mythical landscapes. *Remembrance Sheet of a Conception* 1918 (fig.23), with its fairy-like figures, is exemplary of this moment.

Finally discharged from the army in February 1919 (even though he had returned to civilian life during Christmas 1918), Klee returned to Munich. By now a leading figure in contemporary art, Klee had seen his reputation rise during the war years. The romanticism of his otherworldly compositions, a clear diversion from the brutality of the war, had granted him his first commercial and critical successes.

Establishing a reputation

With growing self-assurance, Klee returned to his art-making. In his rented studio in the Suresnes Castle in Schwabing he began his experimentations with the oil transfer technique (fig.7). A unique combination of drawing, painting and printmaking, the oil transfers consisted of transferring a preliminary drawing to another sheet of paper by means of a tracing technique. Once the transfer process had been completed Klee would rework the image using watercolour, as is the case with *They're Biting* 1920 (fig.24). Between 1919 and 1925 Klee created over 300 works using this system.

In the summer of 1919 Klee visited Zurich to meet members of the Dada circle. As member Marcel Janco recalled, 'in his beautiful work we found all our efforts to unravel the soul of primitive man, to delve into the unconscious and the instinctive power of creation, to discover the pure, direct sources hidden in children'.[12] Janco's emphatic words reveal how, notwithstanding Klee's deliberate isolationism,

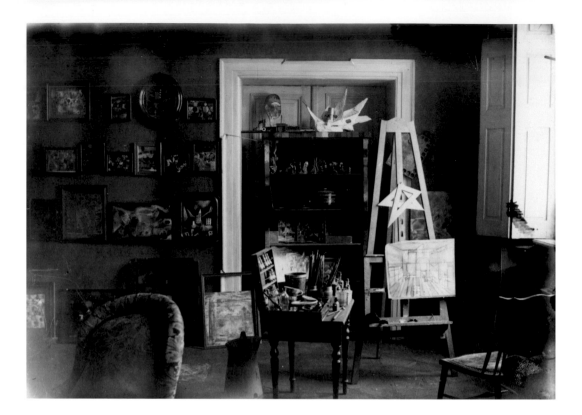

his vision of the universe had a strong impact first on Dada and later on surrealism.

The opening of his first full-scale retrospective exhibition at Hans Goltz's gallery in Munich in May 1920 marked a highpoint in Klee's career. Goltz, a prominent dealer with whom he had entered into a three-year contract the previous year, organised a large retrospective, the first to cover all areas of Klee's oeuvre. Ostensibly the best-known of the works included in the exhibition was *Angelus Novus* 1920 (fig.25). An angel with large and inquisitive eyes, it was purchased the following year by Walter Benjamin who, in his *Theses on the Philosophy of History*, described it as the 'angel of history'.[13]

Almost in conjunction with this retrospective, two monographs devoted to Klee were published: *Paul Klee: Life, Work, Spirit* by Leopold Zahn, and a text in the New Art series by Hermann von Wedderkop. Both were used as promotional tools by Goltz. Wilhelm Hausenstein's *Kairouan or A Tale of the Painter Klee and the Art of*

7. Studio of Paul Klee, Suresnes Castle, Munich, 1920
Zentrum Paul Klee, Bern

This Century (1921) offered an alternative, romanticised portrayal of the artist and his fabled Tunisian journey. The year 1920 ended on a positive note when on 29 October Klee received a telegram offering him a position as a master at the Bauhaus in Weimar.

A master at the Bauhaus

Founded in 1919 by Walter Gropius, the Bauhaus was a pioneering school uniting fine and applied arts. When Klee joined in January 1921 his teaching colleagues included Lyonel Feininger, Oskar Schlemmer, Johannes Itten, Georg Muche, Adolf Meyer, and Gerhard Marcks. Soon after, his friend Kandinsky – with whom Klee maintained the closest relationship – joined the school (fig.8).

The position at the Bauhaus offered Klee the financial stability he had longed for. With a fixed annual salary and a studio space, in addition to improved living conditions, Klee felt appeased by this new arrangement. Lily, who had by now given up her piano

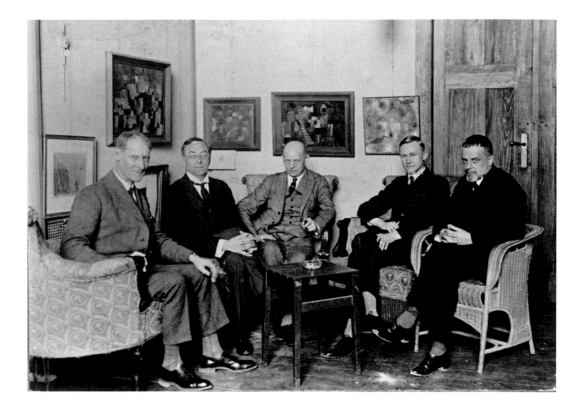

teaching, became an active member of the Bauhaus, while Felix, now fourteen, entered the Bauhaus as its youngest student.

Teaching at the Bauhaus motivated Klee to clarify and organise the theoretical aspects underpinning his work. Until then in fact he had exposed his artistic thinking only in the 'Creative Credo' published in 1920. While maintaining that his work and his teaching occupied different spheres, he nonetheless brought elements of his work such as colour, nature and rhythm into his teaching. Detailed lecture notes that he prepared in advance of each class show the fundamental principles of pictorial creation that he sought to convey to his students. In his lectures on pictorial form Klee emphasised the importance of the investigative process, rather than stressing the relevance of form in its final product. In addition to the foundation course, Klee also acted over the years as form master of various workshops, including, bookbinding, stained glass and weaving.

While Klee enjoyed the privileges associated with his new role he found it hard to reconcile teaching with his work. Doubting whether the two could co-exist, he wrote to Lily: 'Here in the studio I am working on half a dozen paintings, drawing and thinking about my course, all at once, for everything must go together or it wouldn't work at all.'[14] In response to this struggle Klee conceived of his studio as a private retreat to which others were invited only on rare occasions.

In the seclusion of his studio, which was referred to as a wizard's cove, Klee furthered his experiments with colour and form. Of key relevance at this time are the colour gradations. Exploring progression and colour harmony through the repetition and layering of forms, the colour gradations yield a unique analogy between the objects represented and the rhythmic-dynamic sequence of motion they generate. The delicacy of these crystalline colour gradations is seen in *Suspended Fruit* 1921 (fig.27).

Another source of inspiration, and a key aspect of Bauhaus life, were the yearly festivals. Participating mostly as an observer, Klee captured the effervescence of the festivities in works like *Comedy* 1921 (fig.29) where the mechanical-looking figures humorously alluded to the celebrations' extravagant masks and costumes. Felix, meanwhile, participated in the festivities with his puppet theatre, presenting ironic portrayals of Bauhaus life (fig.9).

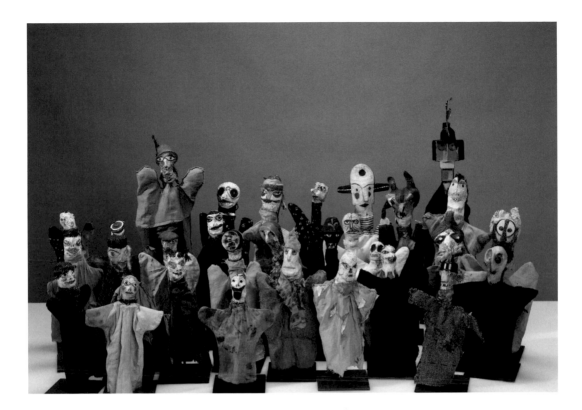

9. Group picture with the
30 hand puppets, 1916–25
Zentrum Paul Klee, Bern

Klee's increasing prestige was confirmed by the large solo exhibition mounted by the Nationalgalerie in Berlin in 1923. Actively involved in the selection of the works and in their arrangement in the rooms, Klee chose to give prominence to his most recent productions. Amongst the works exhibited was *The Twittering Machine* 1921 (fig.31). Depicting a bird-like quartet set in motion by a mechanism similar to a music box, it reflected Klee's interest in the overlap between the mechanical and the natural world. Alongside these figurative works, he exhibited decidedly more abstract-orientated compositions like *Picture of a City (Red-Green Accents)* 1921 (fig.32). A geometric rendering of a cityscape, it foreshadowed the contrasting colour pattern scheme that would dominate Klee's 'magic squares'. The sophistication of this series of works, which vividly contrasts with the purism of De Stijl, is most evident in *Static-Dynamic Gradation* 1923 (fig.35). Based on a distorted grid structure, *Static-Dynamic Gradation* develops with dramatic intensity

from the tertiary planes at the painting's edges towards the central cluster, dominated by bright colours. The rotational symmetry of the composition points to the painting's relationship to music, where the grid pattern stands for the modulations of musical chords.

At the beginning of the following year, Klee delivered his lecture 'On Modern Art' at the Kunstverein in Jena. Applauded for his inspiring words and compelling content, the lecture reinforced Klee's reputation as an important figure of his times. Emboldened by these enthusiastic responses Klee agreed to expand his commercial horizons through contracts with Emmy Esther (Galka) Scheyer. A German émigré, she sought to promote the ideas and work of Feininger, Jawlensky, Kandinsky and Klee, 'The Blue Four', in America. But despite Scheyer's efforts to organise lectures and exhibitions, first in New York and later in Los Angeles, sales remained meagre.

In the meanwhile the Bauhaus was undergoing a period of major upheaval. The victory of the conservative party in the Thuringian state election led to radical cuts in the school's funding, followed by the termination of Gropius's and the masters' contracts. Shortly after the Bauhaus Weimar closed, the city of Dessau stepped in to offer the school new premises.

From Weimar to Dessau

In April 1925 the Bauhaus moved from Weimar to Dessau. There, Gropius was given free rein to design the buildings housing the school and the masters' homes. Klee, who shared a two-family house with Kandinsky, was closely involved in the construction of his master-house and advised on furnishings and tonalities for the interior wall design. The proximity between the two artists during the Dessau years strengthened their friendship. While Klee found this transition positive overall, Lily struggled to adapt to life in Dessau and spent most of her time travelling. Felix, who had by then completed his Bauhaus training, was encouraged by his father to pursue a career in theatre.

Following the transition to Dessau, Klee revised the curriculum by setting up a free painting class. This course steered away from the fixed didactic contents of his Weimar classes and aimed instead at providing a platform for discussion where he could guide students through a process of self-analysis. *The Pedagogical Sketchbook*

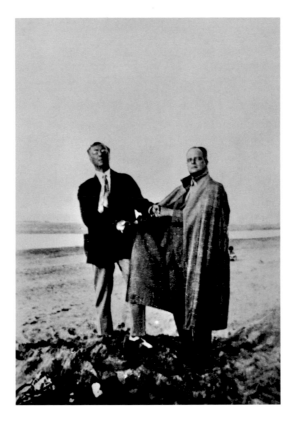

(published in 1925 as part of the Bauhaus Books series edited by
Gropius and designed by László Moholy-Nagy) further fostered Klee's
pedagogical mission. In it Klee famously claimed to be taking 'an
active line on a walk'.[15]

While the popularity of Klee's free painting classes enhanced a
sense of admiration for this wondrous painter, it also confirmed the
rising criticism of his individualism. Ernst Kallai's representation of
Klee as a Buddha in residence with adoring figures on both sides,
ambiguously commented on these conflicting views (fig.11). Hannes
Mayer, Gropius's successor, was outspoken against Klee's growing
reputation. A radical functionalist, he questioned the very pertinence
of traditional painting in the school's increasingly rational orientation.

Decidedly more enthused by Klee's aesthetic were the surrealists,
who had hailed him as a mentor since the early 1920s. It was not until
October 1925, however, that they had the opportunity to see a solo

exhibition of Klee's work in Paris. This exhibition, held at the Galerie Vavin-Raspail, confirmed the surrealists' belief that Klee's idiom, with its poetical dream-like compositions and 'unmediated' graphic approach, could function as a catalyst to their own work. The dealer Alfred Flechtheim, who now represented Klee, reinforced this image of the artist as a master of the unconscious, overlooking his role in the constructive-oriented Bauhaus.

Klee's works from this time – for example, the enchanted fish paintings – appeared more akin to the surrealist sensibility rather than to the rational lines preached by the Bauhaus. *The Goldfish* 1925 (fig.38) with its luminous golden fish set against a jewel-like backdrop, highlights Klee's ongoing fascination with the natural realm. Similarly enveloped by a fantastical atmosphere are the compositions featuring ships that he painted upon returning from a holiday on Porquerolles and Corsica (figs.12, 42).

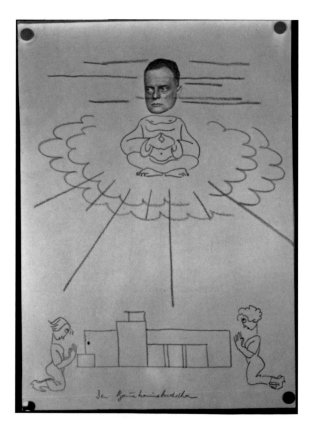

11. Ernst Kallai
The Bauhaus Buddha
1928–9
Collage
Bauhaus-Archiv, Berlin

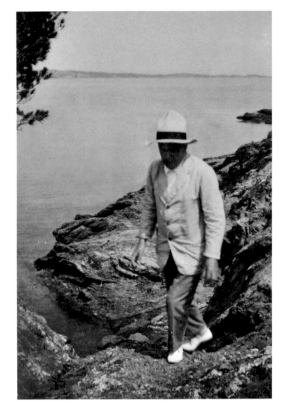

More resonant with the spare, abstract aesthetic preached
by Moholy-Nagy are the paintings that Klee produced following
his month-long visit to Egypt. Awestruck by the rich quality of
the Egyptian light, he conveyed his atmospheric impressions in a
series of stripe paintings. A study of rhythm and proportion, with
its juxtaposition of staggered horizontal lines, *Steps* 1929 (fig.44)
stands out as one of the key works produced after his return from
this second African experience.

The visit to Egypt, made possible by the members of the Klee
society, was the most welcome of the gifts he received for his fiftieth
birthday. On 18 December 1929 Klee turned fifty, and to mark the
event his colleagues and students at the Bauhaus organised a rich
and imaginative celebration, the highpoint of which was the delivery
of his birthday present by parachute over his studio. Despite the
eventfulness of the festivity, Klee was not altogether comfortable

with all this excitement and gladly retreated to the safe premises of his studio. Klee's coolness was, above all, an expression of the period of turmoil the artist was experiencing. Unhappy with his declining reputation at the Bauhaus he soon found relief in the invitation to teach at the Kunstakademie in Düsseldorf, which he joined in 1931 (fig.13).

Düsseldorf interlude

Despite being positively satisfied with his new teaching post at the Kunstakademie and equally thrilled by the many sources of entertainment, including an excellent opera house, that a larger city like Düsseldorf offered him, Klee would not settle permanently in the city until the spring of 1933 (fig.14). Between 1931 and 1933, in fact, he commuted every two weeks between Düsseldorf and Dessau, where he still retained his old master house and studio. Happy with the idea of maintaining two studios of radically different scale, Klee found this life on the move very stimulating – to the point that he only sought to move permanently to Düsseldorf in 1933 because of new residency obligations.

Between Dessau and Düsseldorf Klee created one of his most remarkable groups of works, the polyphonic pointillist paintings. Conveying a rhythm of concordant and dissonant chords through the overlay of individual coloured dots, these pictorial structures provided a visual counterpart to musical polyphony. *Polyphony* 1932 (fig.48) whose programmatic title acted as a manifesto for the group of approximately seventy pointillist paintings, combined a foundation of coloured bricks with an overlay of smaller coloured dots. The result was a vibrant structure reverberating between the two pictorial layers. Reminiscent of the pointillist experiments of post-impressionist painter Seurat, Klee's pointillism strayed from the scientific-led investigation of high pointillism and approached the rhythmic interaction of his composition from a purely formal perspective. Klee's pointillism served both abstract and figurative motifs. Exemplary of the latter's manifestation is *Ad Parnassum* 1932 (fig.49) the last of the pointillist works. Here Mount Parnassus, famed through Greek mythology, emerges from the careful weaving of finely tuned gem-like dots.

13. Paul Klee, Dessau,
c.1932 (detail)
Zentrum Paul Klee, Bern

A degenerate artist

On 30 January 1933, with the appointment of Adolf Hitler as chancellor of Germany, the Nazi Party came to power. Despite his prevalently apolitical stance, Klee deeply despised Hitler and together with the director of the Kunstakademie soon became the target of National Socialist attacks. In his absence his Dessau house was searched and items confiscated. His contract at the Kunstakademie was soon terminated and Klee and Lily decided to seek refuge in Switzerland.

After hastily selling off most of their belongings, Lily and Klee returned to his father's home in Bern on 23 December 1933 after an absence of more than twenty years. Despite being born in Switzerland, Klee was a German citizen and had to formally apply for Swiss citizenship, a lengthy process that was resolved only after his death.

Klee's personal and cultural existence suddenly came apart. He had lost the financial security and the prestige associated with a teaching post. His artistic community was being dispersed and his dealer Flechtheim, a Jew, closed his Düsseldorf and Berlin galleries and fled to avoid Nazi persecution. Klee managed to secure the support of the Parisian-based dealer Daniel-Henry Kahnweiler, but the art market was going through uncertain times and sales were at a standstill. The impending financial hardships forced Klee and Lily to seek more modest accommodation, and in spring 1934 they moved into a three-room apartment in Bern (fig.15).

Notwithstanding the economical and psychological turmoil, Klee and Lily soon became active members of the local cultural scene and with the retrieval of his pictorial tools the artist promptly set back to work. Leaving behind the refinement of his pointillist

14. Paul Klee studying a painting, from Petra Petitpierre's photo album Zentrum Paul Klee, Bern

works, Klee turned to a simplified vocabulary of signs and subdued tones. Contemporary political events entered only transversally his artistic production and the only explicit comments remained embedded in a series of figurative drawings he had begun while at the Kunstakademie. In Bern, ostensibly in an attempt to overcome the shock of recent events, Klee rediscovered earlier motifs and brought them back in new configurations. *Flowering* 1934 (fig.51), a revised 'magic square', belongs to this period.

Flowering was one of over 300 works exhibited in Klee's retrospective at the Kunsthalle Bern in 1935. Such a major presentation was aimed at reinforcing Klee's standing amongst Swiss audiences. Whilst his international fame continued to rise – thanks to exhibitions at The Museum of Modern Art (1930) in New York and at the Mayor Gallery (1934) in London Klee anxiously sought critical and economic recognition in Switzerland. Despite his efforts the reactions were mixed and sales meagre.

Disappointed but still determined, Klee continued with technical experiments. Only worsening health conditions temporarily halted his creative force in 1936, when his catalogue raisonné registered only twenty-five works. Later, diagnosed with a degenerative autoimmune disorder known as scleroderma, Klee would devote his final few years entirely to his art, producing over a thousand works in 1939 alone (fig.16). His pictorial idiom registered Klee's changing physical and psychological condition. Drawing on a vocabulary of simplified lines and signs, he created works such as *Secret Lettering* 1937 (fig.54), in which disparate ciphers of an unknown language take over the picture plane. The angel paintings, with their obvious religious connotations, stand on the opposite end of Klee's artistic spectrum at this time. As mythical figures they nod both to an impending death and a struggle for survival (fig.59).

With numerous of his works confiscated from German art collections and his forced participation in the Entartete Kunst (Degenerate Art) exhibition in Munich in 1937, Klee had been labelled a degenerate artist by the Nazis. This labelling signalled the apex of political upheavals he suffered in this period.

While the Nazis condemned him as a degenerate, Americans welcomed him as a master. Klee's sales in America, modest until then, had improved substantially with the emigration of Berlin dealers Karl

Nierendorf and Curt Valentin. The dealers' outspoken rivalry had contributed to his American exposure and it was especially thanks to Nierendorf that Klee's work would play a seminal role in post-war years. In the meantime, back in Bern, Klee welcomed visits from friends and peers, including Kandinsky and his wife Nina, whom he hadn't seen since he left Dessau. A three-day festivity marked Klee's sixtieth birthday on 18 December 1939.

Despite Klee's declining physical health, he was actively involved in the conception of the large exhibition mounted by the Kunsthaus Zurich in February 1940. A few months before the opening, the artist resolved to show solely his production from the last five years

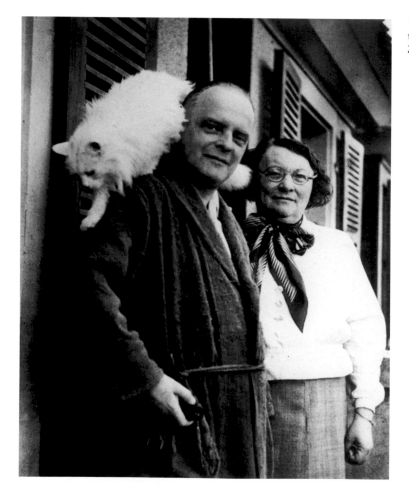

15. Paul and Lily Klee with the cat Bimbo, Bern, 1935
Zentrum Paul Klee, Bern

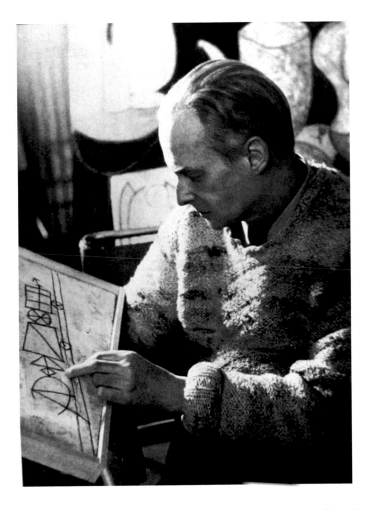

instead of presenting a survey of his entire career as originally planned. Too ill to attend the opening, Klee visited shortly before the exhibition closed in March 1940. A few weeks later, increasingly weakened, he left Bern to seek medical treatment in Locarno, but a heart failure ended his life on 29 June 1940. An artist of extreme variety, Paul Klee left behind an outstanding oeuvre, which was and still is a revelation to many.

17
Winged Hero 1905
Etching
25.5 × 16
Zentrum Paul Klee, Bern

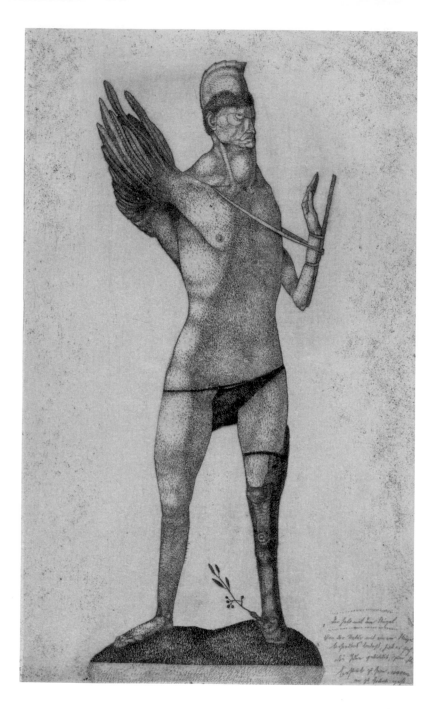

18
*Stand, Watering Can
and Bucket* 1910
Watercolour on paper
on cardboard
13.9 × 13.3
Städtische Galerie im
Lenbachhaus, Munich

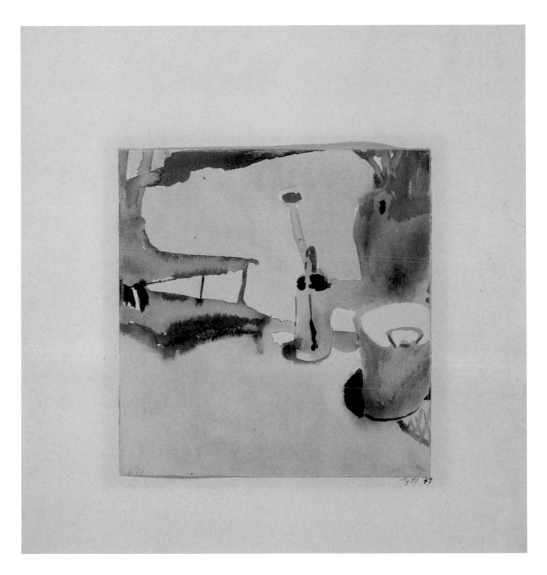

19
Flower Bed 1913
Oil on cardboard
28.2 × 33.7
Solomon R. Guggenheim
Museum, New York

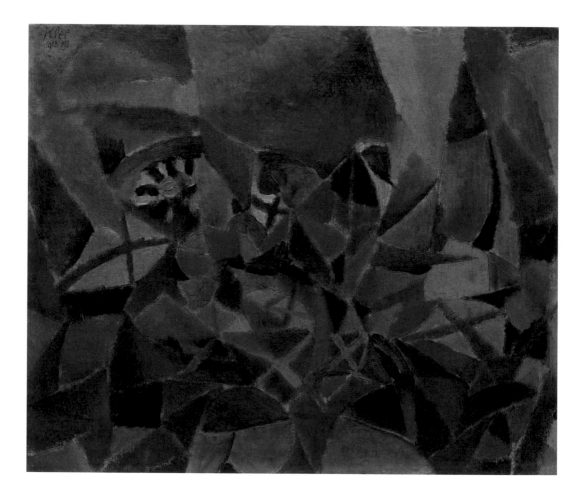

20
St Germain near Tunis 1914
Watercolour and pencil
on paper on cardboard
18.5 × 24
Museum Sammlung
Rosengart, Lucerne

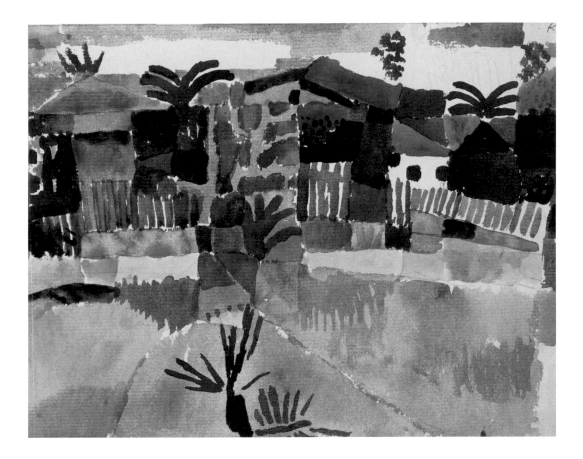

21
Landscape with Flags 1915
Watercolour, oil and
graphite on tissue
mounted on cardboard
23.3 × 28.3
Sprengel Museum,
Hannover

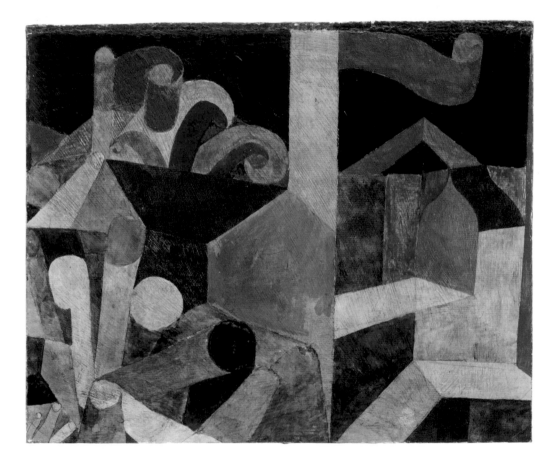

22
Persian Nightingales 1917
Watercolour, gouache,
pen and pencil on paper
on cardboard
22.8 × 18.1
National Gallery of Art,
Washington DC

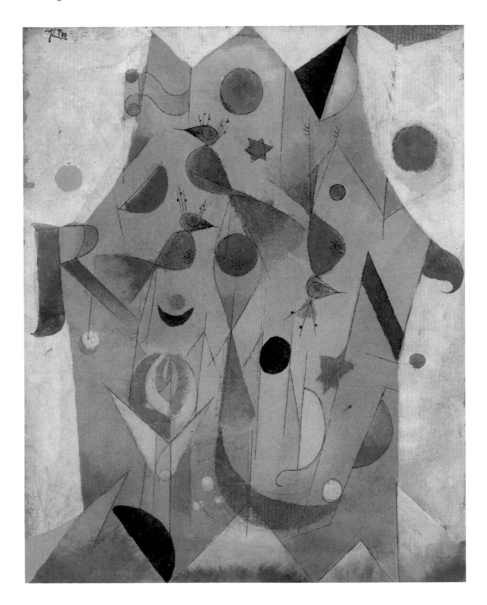

23
*Remembrance Sheet
of a Conception* 1918
Watercolour, gouache and
India ink on wove papers,
mounted on cardboard
25.7 × 16.8
Norton Simon Museum,
Pasadena

24
They're Biting 1920
Watercolour and oil
on paper
31.1 × 23.5
Tate

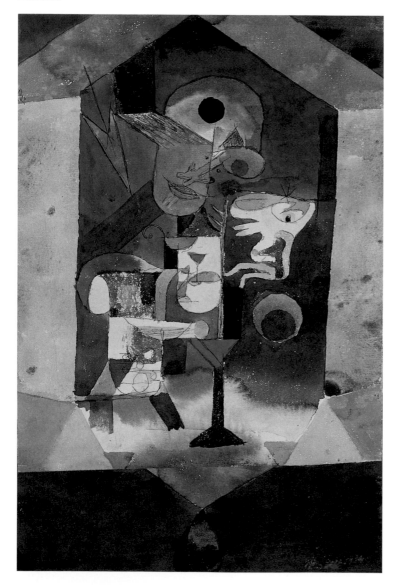

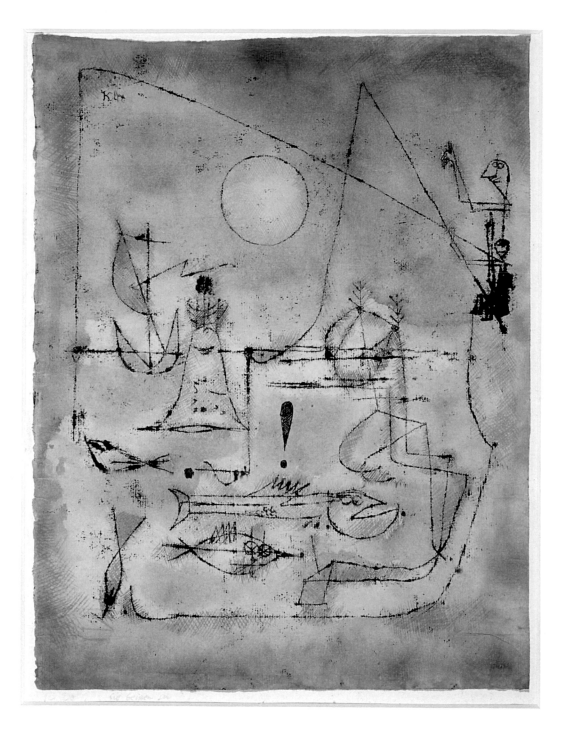

25
Angelus Novus 1920
Oil transfer drawing and
watercolour on paper
on cardboard
31.8 × 24.2
The Israel Museum,
Jerusalem

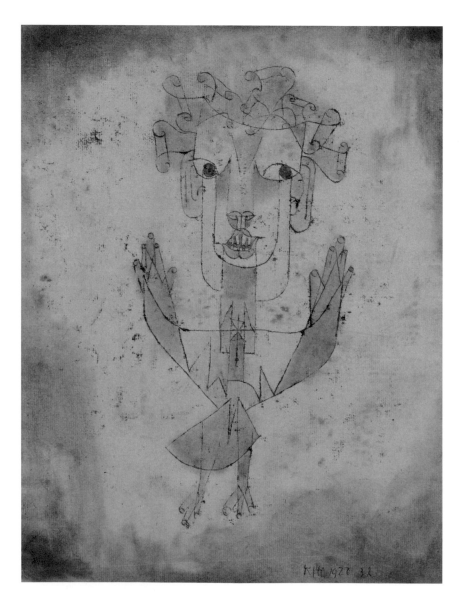

26
Redgreen and Violet –
Yellow Rhythms 1920
Oil and ink on cardboard
37.5 × 34
The Metropolitan Museum
of Art, New York

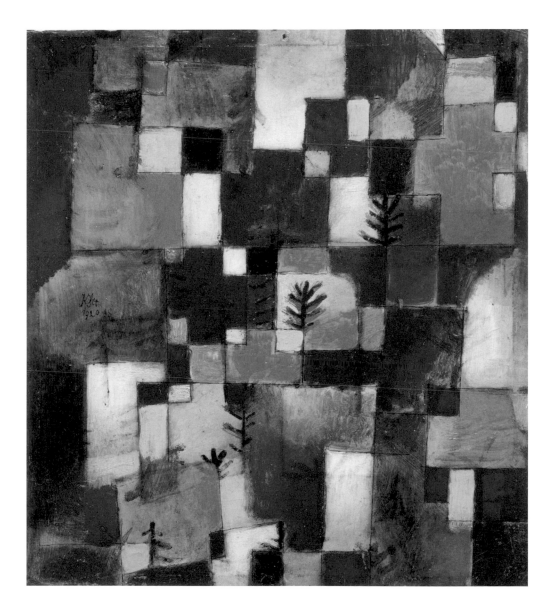

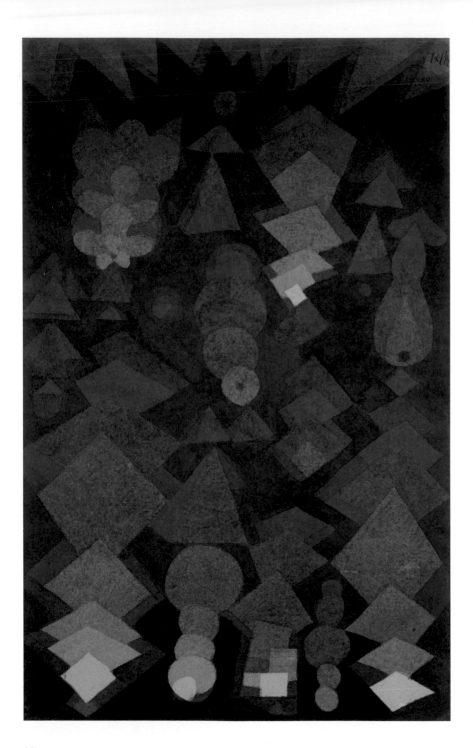

27
Suspended Fruit 1921
Watercolour and graphite
on paper
24.8 × 15.2
The Metropolitan Museum
of Art, New York

28
*Gradation Red-Green
Vermilion* 1921
Watercolour and ink
on paper
24.4 × 31.1
The Pierpont Morgan
Library, New York

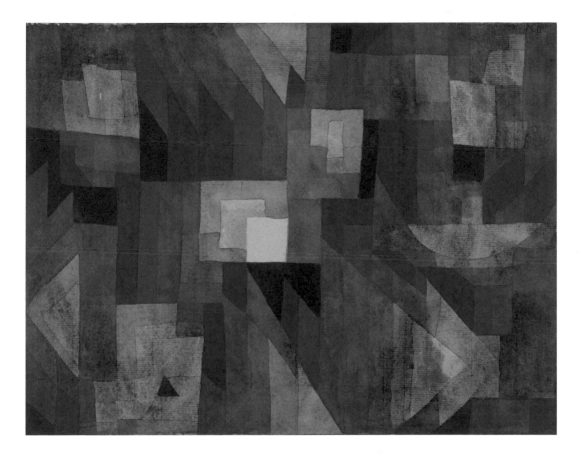

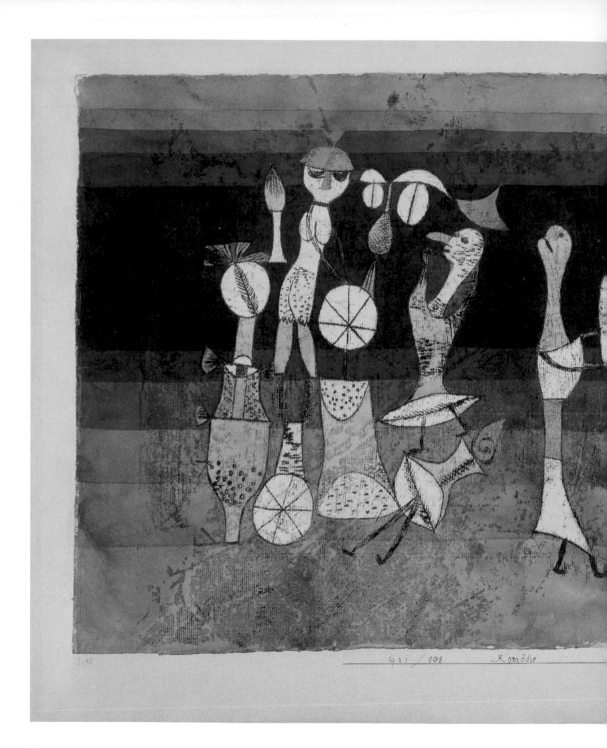

1921 / 108 Komödie

29
Comedy 1921
Watercolour and oil
paint on paper
30.5 × 45.4
Tate

30
Primeval-World Couple
1921
Oil transfer drawing and
watercolour on paper,
bordered with ink,
spots of glue, mounted
on cardboard
31.5 × 48
Bayerische
Staatsgemäldesammlungen,
Pinakothek der Moderne

31
The Twittering Machine
1921
Oil transfer drawing,
watercolour and ink on
paper with gouache and
ink borders on board
64.1 × 48.3
The Museum of Modern
Art, New York

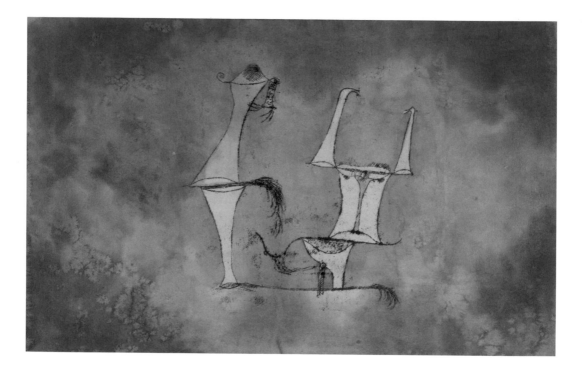

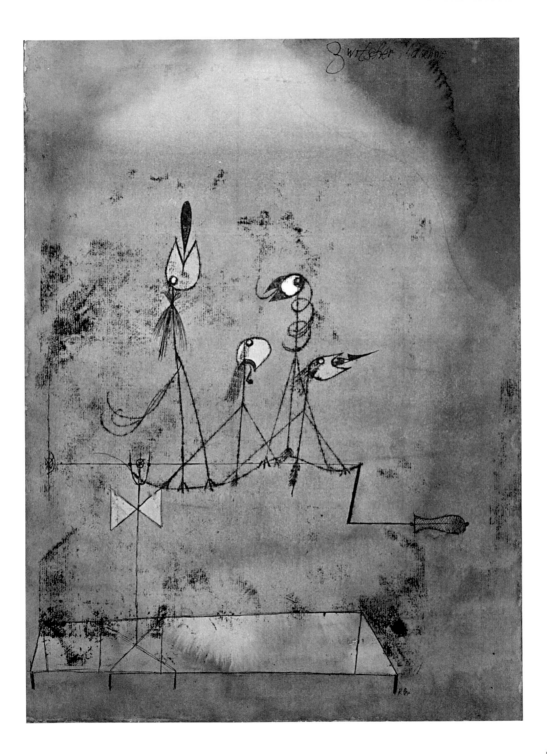

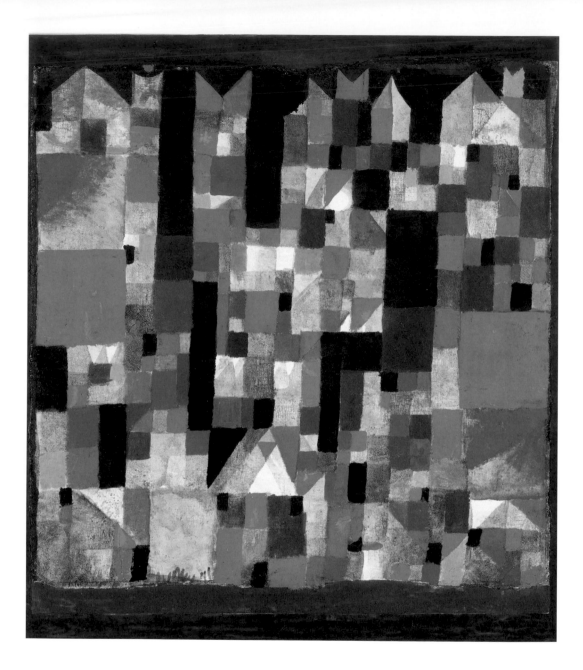

44

32
Picture of a City (Red-Green Accents) 1921
Oil painting on plaster priming on gauze, bordered with gouache mounted on cardboard
42 × 42.5
Staatsgalerie Stuttgart

33
A Young Lady's Adventure
1922
Watercolour and ink on
paper, bordered with
gouache and pen mounted
on cardboard
43.8 × 31.1
Tate

34
*Analysis of Diverse
Perversities* 1922
Ink and watercolour
on paper mounted
on cardboard
47 × 31.4
Centre Pompidou

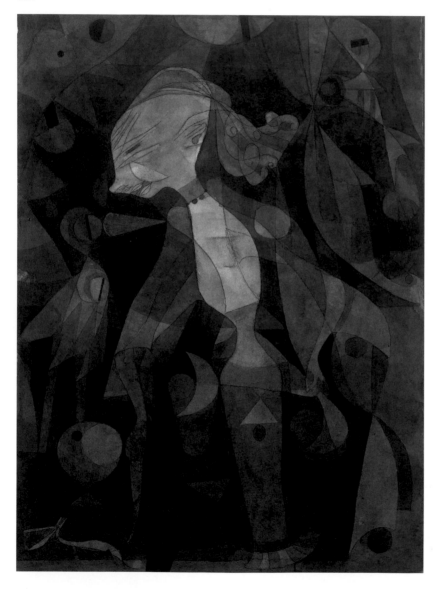

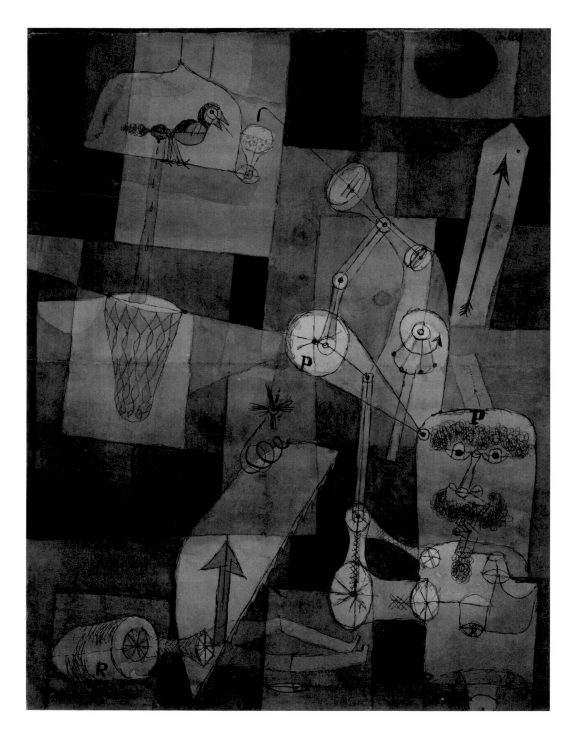

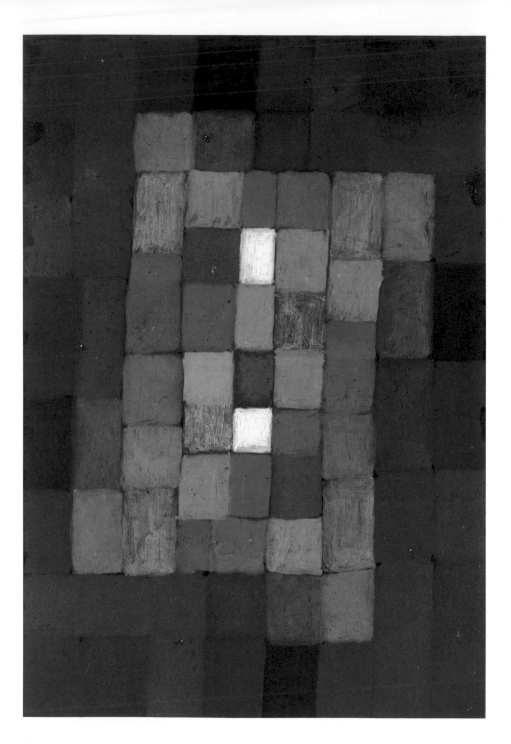

35
Static-Dynamic Gradation
1923
Oil and gouache on paper,
bordered with gouache,
watercolour, and ink
38.1 × 26.1
The Metropolitan Museum
of Art, New York

36
Assyrian Game 1923
Oil on cardboard
37 × 51
Private Collection on loan to
Zentrum Paul Klee

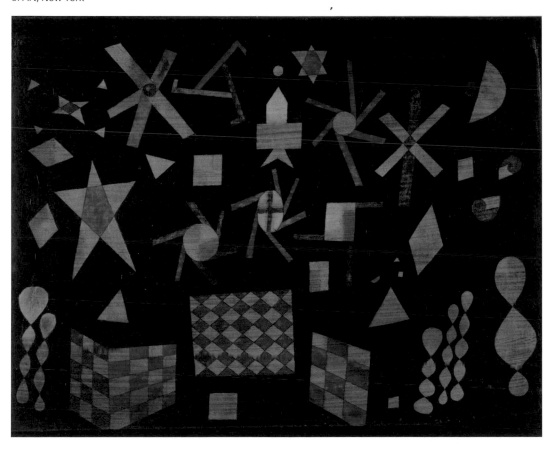

37
Battle Scene from the
Comic-Fantastic Opera
'The Seafarer' 1923
Oil, graphite, watercolour
and gouache on paper,
bordered with watercolour,
ink and gouache, mounted
on cardboard
34.5 × 50
Kunstmuseum Basel,
Kupferstichkabinett

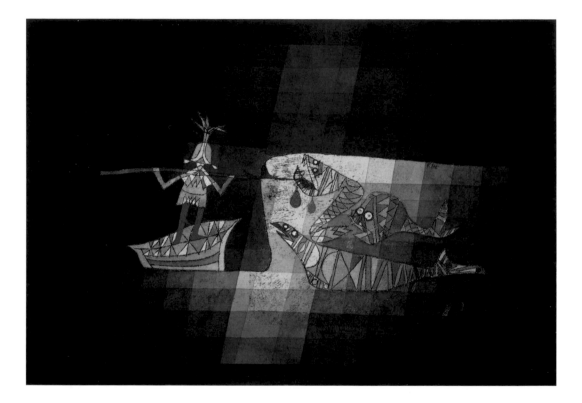

38
The Goldfish 1925
Oil and watercolour on
paper on cardboard
49.6 × 9.2
Hamburger Kunsthalle

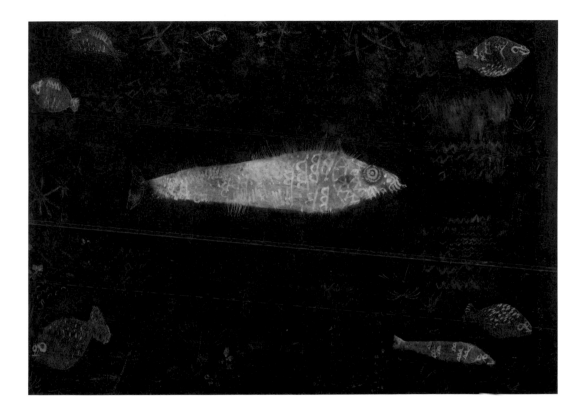

39
Sacred Islands 1926
Ink and watercolour on
paper on board
63.2 × 47
The Museum of Modern
Art, New York

40
Portrait of an Artist 1927
Oil and collage on
cardboard over wood with
painted plaster border
63.2 × 40
The Museum of Modern
Art, New York

54

41
Pastorale (Rhythms) 1927
Tempera on canvas
mounted on wood
69.3 × 52.4
The Museum of Modern
Art, New York

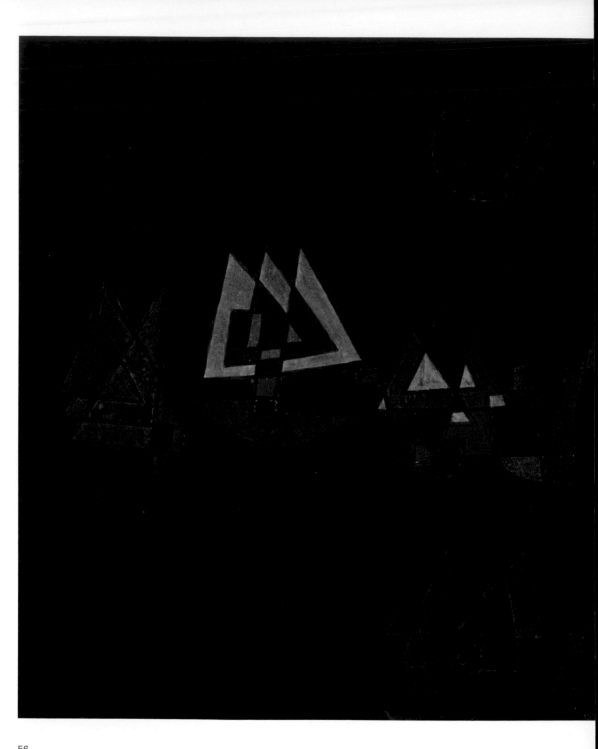

42
Ships in the Dark 1927
Oil on canvas
42.7 × 59
On loan to Tate

43
In the Current Six Weirs
1929
Oil and tempera on canvas
43.5 × 43.5
Solomon R. Guggenheim
Museum, New York

44
Steps 1929
Oil and ink on canvas
52 × 43
Moderna Museet,
Stockholm

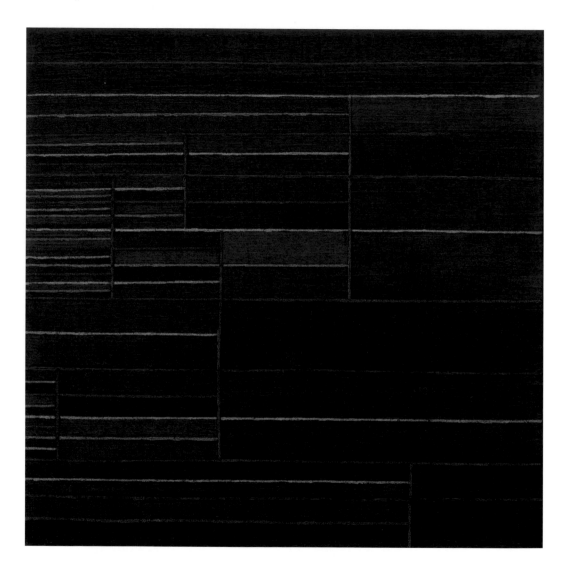

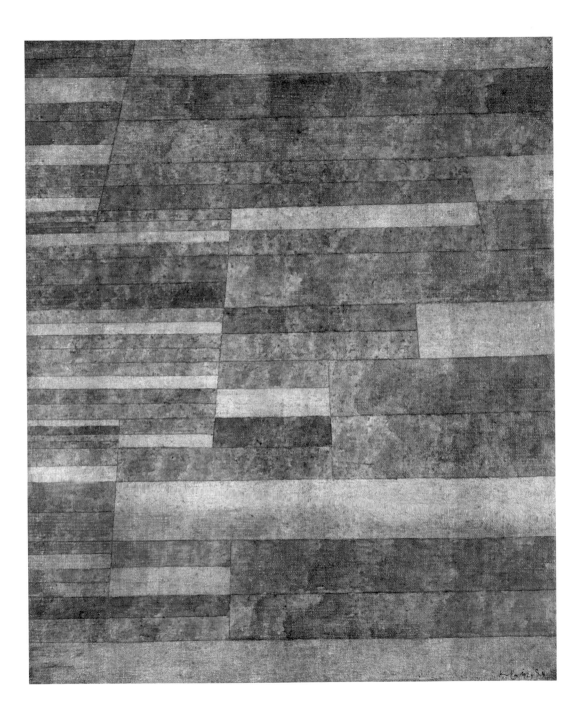

45
Dispute 1929
Oil on canvas
67 × 67
Zentrum Paul Klee, Bern

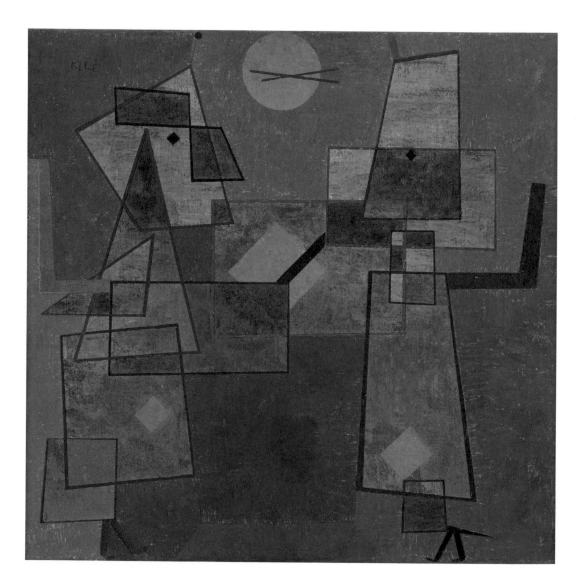

46
*Puppets (Colourful on
Black)* 1930
Oil on cardboard
32 × 30.5
Kunsthaus Zurich

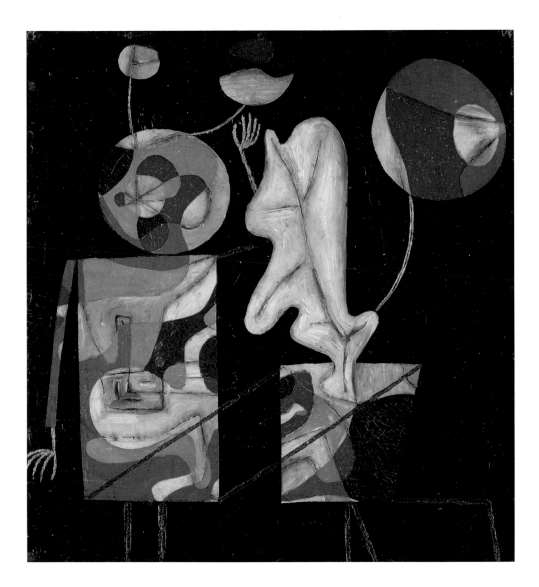

47
Clarification 1932
Oil on canvas
70.5 × 96.2
The Metropolitan Museum
of Art, New York

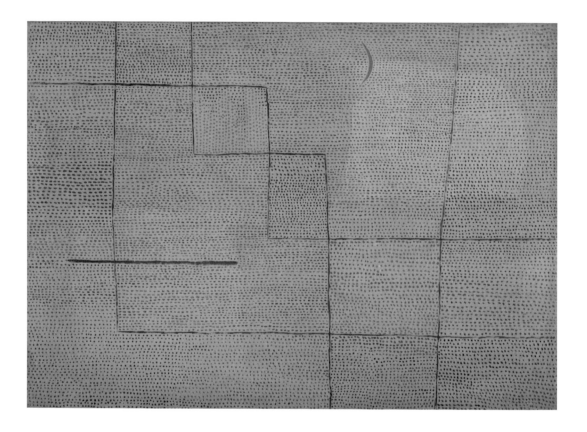

48
Polyphony 1932
Oil and chalk on canvas
66.5 × 106
Kunstmuseum Basel.
On permanent loan from
the Emanuel Hoffman
Foundation

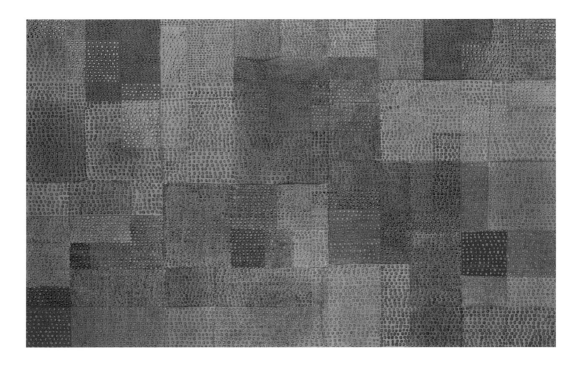

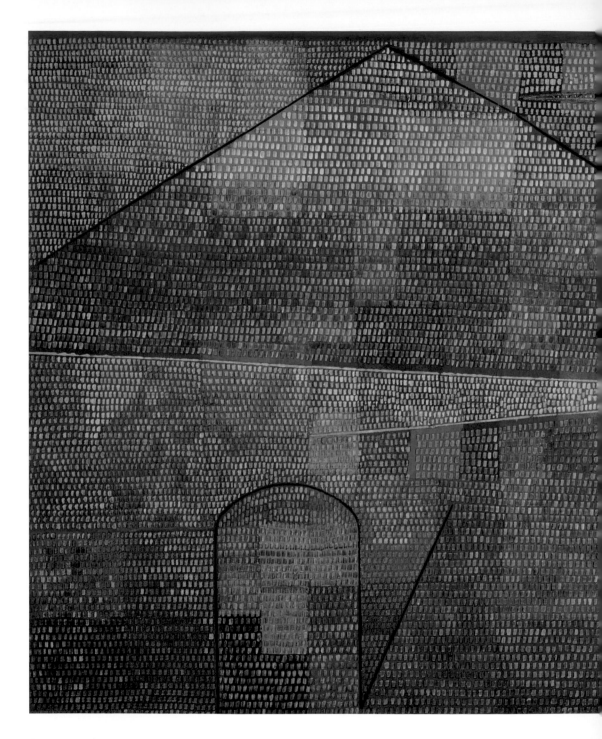

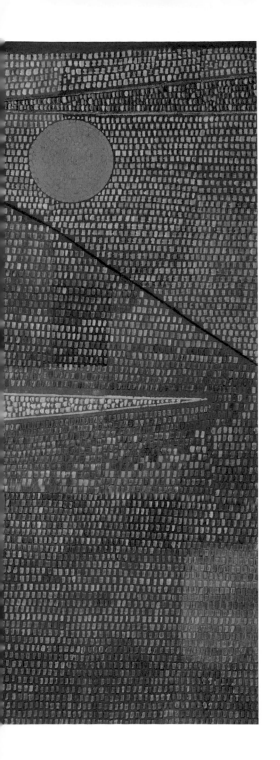

49
Ad Parnassum 1932
Oil and casein paint on
canvas
100 × 126
Kunstmuseum Bern

50
Fire at Full Moon 1933
Watercolour on coloured
paste on grounded canvas
50 × 65
Museum Folkwang, Essen

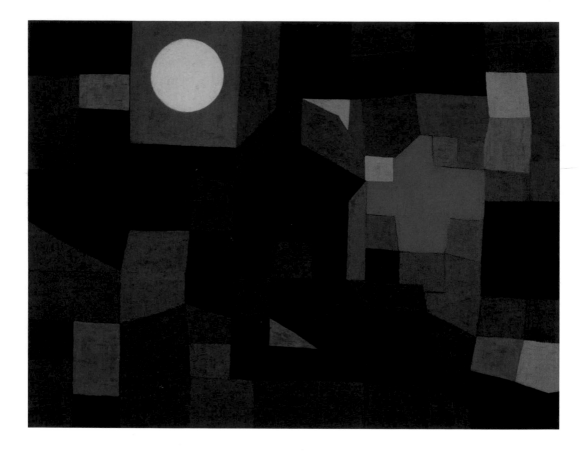

51
Flowering 1934
Oil on primed canvas
81.5 × 80
Kunstmuseum Winterthur

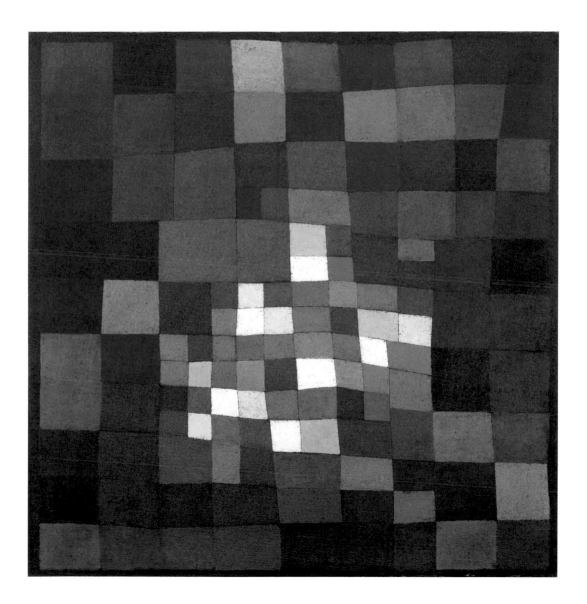

52
Fear 1934
Gouache and wax
on burlap
49.9 × 60
National Gallery of
Canada, Ottawa

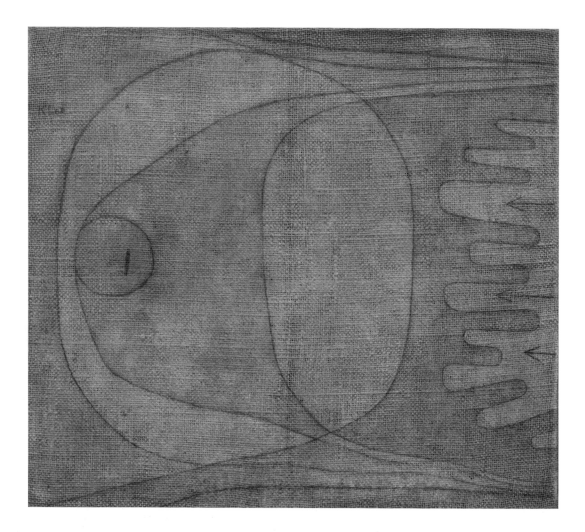

53
Walpurgis Night 1935
Gouache on fabric
on plywood
50.8 × 47
Tate

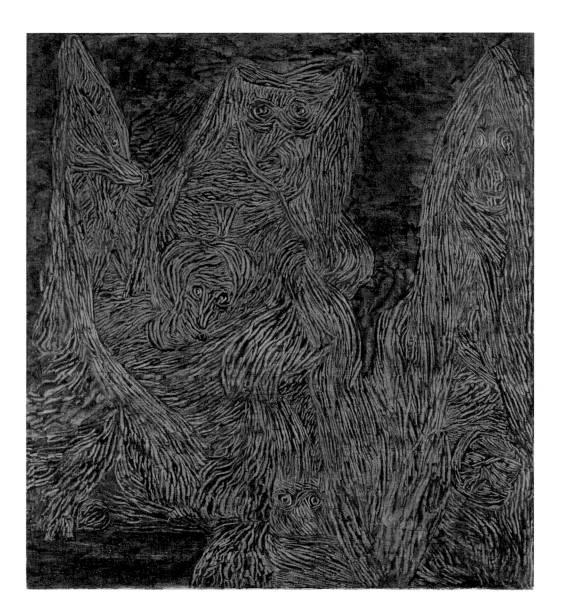

54
Secret Lettering 1937
Charcoal and paste on
primed paper
48.5 × 33
Daros Collection, Zurich

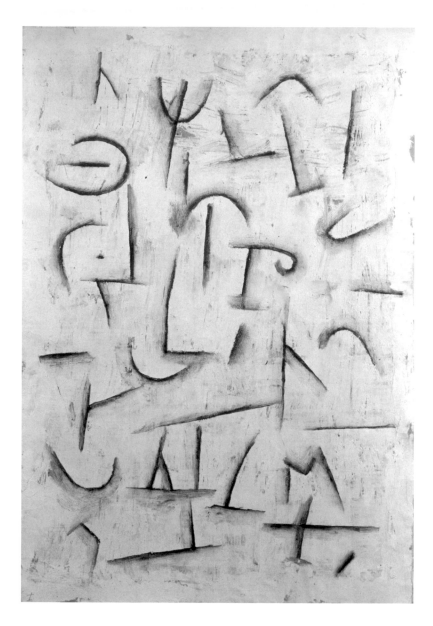

55
Blue Night 1937
Pastel on cotton on
coloured paste on burlap
50.5 × 76.5
Kunstmuseum Basel

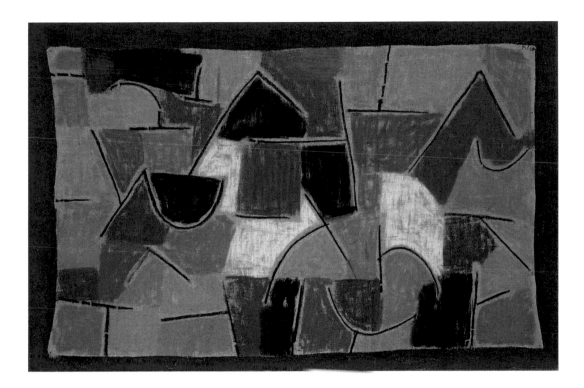

56
Rich Harbour 1938
Oil and coloured paste on
drawing paper mounted
on burlap
75.5 × 165
Kunstmuseum Basel

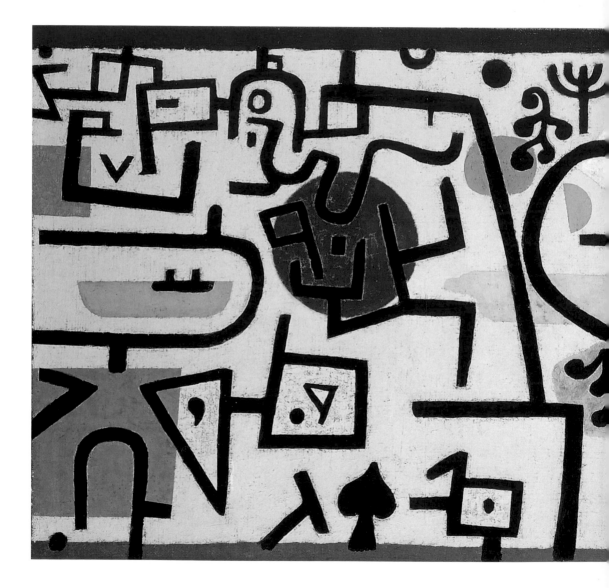

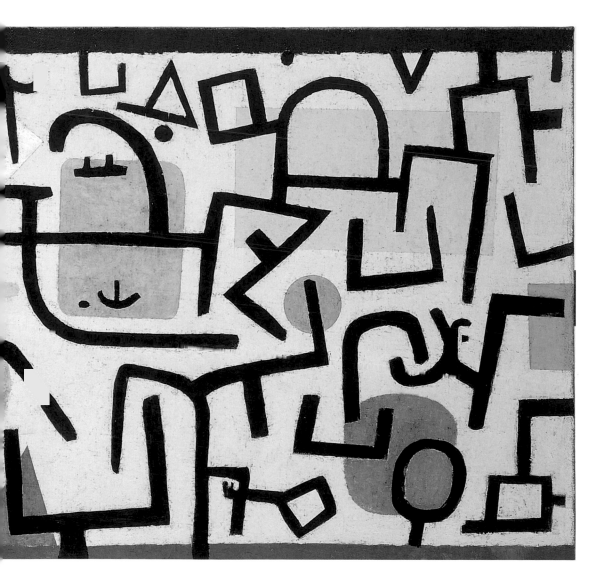

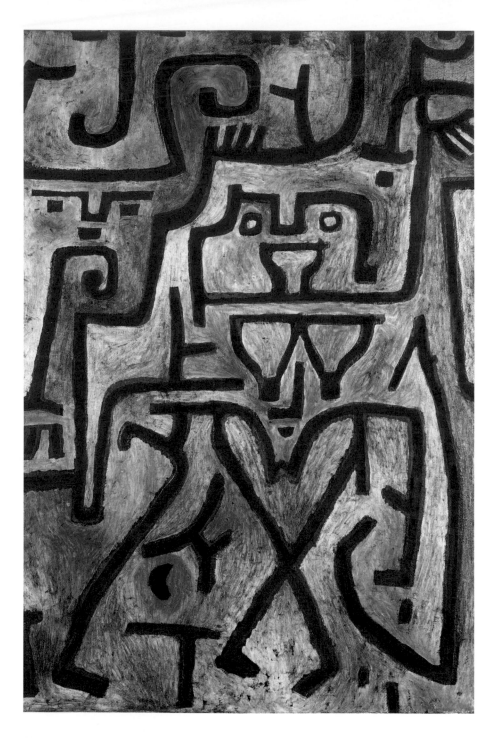

57
Forest Witches 1938
Oil on paper on burlap
99 × 74
Fondation Beyeler, Basel

58
Outbreak of Fear III 1939
Watercolour on primed
paper on cardboard
63.5 × 48.1
Zentrum Paul Klee, Bern

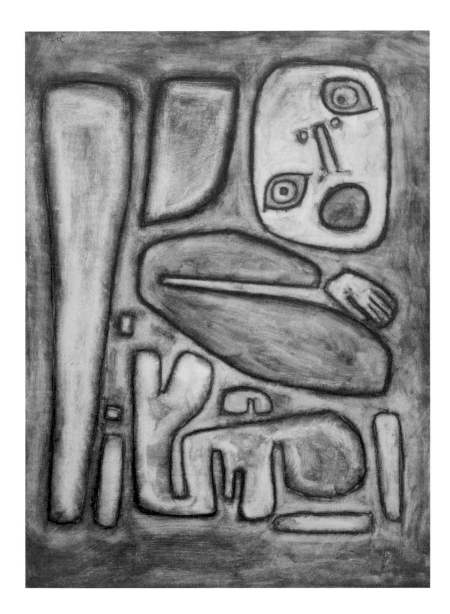

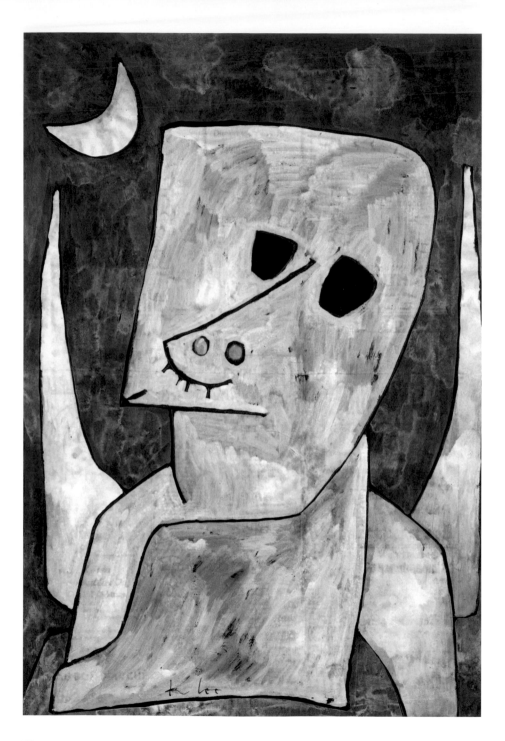

59
Angel Applicant 1939
Gouache, ink and pencil
on paper
48.9 × 34
The Metropolitan Museum
of Art, New York

60
Twilight Flowers 1940
Wax colour on burlap
mounted on a second
burlap
35 × 80
Kunstmuseum Bern

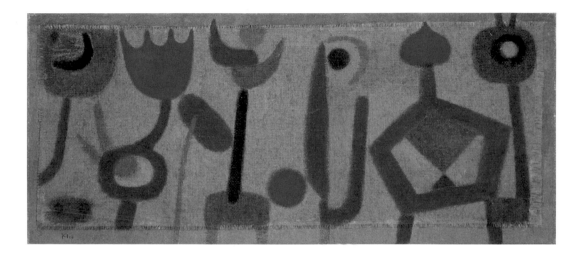

Notes

1. Paul Klee, 'Creative Credo', originally *Shöpferische Konfession,* trans., in Jürg Spiller (ed.), *Paul Klee: The thinking eye*, London 1961, revised edn 1964, p.76.

2. Joan-Josep Tharrats in *Paul Klee*, exh. cat., IVAM Centre Julio González, Valencia 1998, p.280.

3. This text is indebted to the following detailed accounts of Paul Klee's life and work found in: Christine Hopfengart and Michael Baumgartner (eds.), *Paul Klee: Life and Work*, Bern 2012, pp.7–343; Carolyn Lachner (ed.), *Paul Klee*, exh. cat., The Museum of Modern Art, New York 1987, pp.7–344; Sabine Rewald, *Paul Klee: The Berggruen Klee Collection in The Metropolitan Museum of Art*, The Metropolitan Museum of Art, New York 1988.

4. Klee's diaries date from 1897 to 1919, but are heavily edited and revised throughout this period. Felix Klee (ed.), *The Diaries of Paul Klee: 1898–1918*, London 1965, no.63, p.21.

5. Autobiographical text for Wilhelm Hausenstein quoted in Bern 2012, p.20.

6. Klee 1965, no.122, p.42.

7. Hopfengart and Baumgartner 2012, p.38.

8. Klee 1965, no.903, p.265.

9. Klee 1965, no.926, p.297.

10. Klee 1965, no.952, p.313.

11. Klee, no.951, p.313.

12. Marcel Janco, 'Schöpferische Dada', in Willy Verkauf, Marcel Janco and Hans Bolliger (eds.), *Dada: Monographie einer Bewegung*, Teufen 1965, p.40.

13. Walter Benjamin, 'Theses on the Philosophy of History', in Hannah Arendt (ed.), *Illuminations*, New York 1969, pp.257–8.

14. Letter from Paul Klee to Lily Klee, 3 December 1921, reprinted in Spiller 1961, p.32.

15. Paul Klee, *Pedagogical Sketchbook*, London 1968, p.16.

Index

A
Ad Parnassum 22; fig.49
Analysis of Diverse Perversities fig.34
Angel Applicant 25; fig.59
Angelus Novus 14; fig.25
artistic training 6
Assyrian Game fig.36

B
Battle Scene from … 'The Seafarer' fig.37
Bauhaus 15–22; fig.8
Benjamin, Walter 14
Bern 5–6, 7, 23–7
Blaue Reiter 10–11; fig.5
Blue Four 18
Blue Night fig.55
Braque, Georges 11

C
Clarification fig.47
colour 6, 8, 11–12, 16
Comedy 16; fig.29
Corsica 20
'Creative Credo' 5, 16
Cubism 11

D
Dada 13–14
Delaunay, Robert 11
La Lumière 11
Dessau 18–23
Dispute fig.45
drawing 5–6, 8, 11
Düsseldorf 22–3

E
Egypt 21
exhibitions
 1910 Bern 9
 1912 Blaue Reiter 11
 1914 New Munich Secession 12
 1920 retrospective 14
 1923 Nationalgalerie Berlin 17
 1925 Paris 19–20
 1930 MoMA New York 25
 1934 London 25
 1935 retrospective 25
 1937 Degenerate Art 25
 1940 Zurich 26–7

F
Fear fig.52
Feininger, Lyonel 15, 18; fig.8
Fire at Full Moon fig.50
Flechtheim, Alfred 20, 24
Flower Bed fig.19
Flowering 25; fig.51
Forest Witches fig.57

G
The Goldfish 20; fig.38
Goltz, Hans 14
Gradation Red-Green Vermilion fig.28
Gropius, Walter 15, 18, 19

H
Haller, Hermann 6–7; fig.2
Hausenstein, Wilhelm 14–15
Hitler, Adolf 23

I

In the Current Six Weirs fig.43
individualism 11, 13, 19
Inventions 7; fig.17
Italy 6–7; fig.2
Itten, Johannes 15

J

Janco, Marcel 13
Jawlensky, Alexej von 18

K

Kahnweiler, Daniel-Henry 24
Kallai, Ernst
The Bauhaus Buddha 19; fig.11
Kandinsky, Nina 26
Kandinsky, Wassily 9–10, 12, 15, 18, 26; figs.8, 10
Klee, Felix (son) 8, 16, 18; fig.4
Klee, Hans (father) 5, 6
Klee, Ida Marie Frick (mother) 5
Klee, Lily (wife) 6, 7, 8, 15–16, 18, 23, 24; figs.3, 15
Knirr, Heinrich 6
Kubin, Alfred 9
Kunstakademie Düsseldorf 22–3

L

Landscape with Flags 13; fig.21
lectures 16, 18

M

Macke, August 9, 11, 12
Marc, Franz 10, 12–13
Marcks, Gerhard 15
Mayer, Hannes 19
Meyer, Adolf 15
Moholy-Nagy, László 19, 21
Moilliet, Louis 9, 11
Muche, Georg 15; fig.8
Munich 6–7, 8, 12, 13
music 5, 6

N

Nazi Party 23–4, 25
New Munich Secession 12
Nierendorf, Karl 25–6

O

oil transfers 13; fig.24
'On Modern Art' 18
Outbreak of Fear III fig.58

P

painting 11–12
Pastorale (Rhythms) fig.41
The Pedagogical Sketchbook 18–19
Persian Nightingales fig.22
Picasso, Pablo 11
Picture of a City (Red-Green Accents) 17; fig.32
pointillism 22
polyphonic pointillist paintings 22; figs.47–9
Polyphony fig.48
Porquerolles 20
Portrait of an Artist fig.40
Primeval-World Couple fig.30
Puppets (Colourful on Black) fig.46

R

Redgreen and Violet-Yellow Rhythms fig.26
Remembrance Sheet of a Conception 13; fig.23
Rich Harbour fig.56

S

Sacred Islands fig.39
St Germain near Tunis 12; fig.20
Scheyer, Emmy Esther 18
Schlemmer, Oskar 15; fig.8
scleroderma 25
Secret Lettering 25; fig.54
SEMA 9
Seurat, Paul 22
Ships in the Dark 20; fig.42
simultaneity 11
sketchbooks 5–6
Stand, Watering Can 8; fig.18
Static-Dynamic Gradation 17–18; fig.35
Steps 21; fig.44
Stuck, Franz von 6
surrealism 14, 19–20
Suspended Fruit 16; fig.27

T

They're Biting 13; fig.24
Tunisia 11–12
Twilight Flowers fig.60
The Twittering Machine 17; fig.31

V

Valentin, Curt 26

W

Walden, Herwarth 11
Walpurgis Night fig.53
watercolour 8, 11–12, 13
Wedderkop, Hermann von 14
Weimar 15–18; fig.8
Winged Hero 7; fig.17
World War I 12–13

Y

A Young Lady's Adventure fig.33

Z

Zahn, Leopold 14

First published 2013 by order of the Tate Trustees
by Tate Publishing, a division of Tate Enterprises
Ltd, Millbank, London SW1P 4RG
www.tate.org.uk/publishing

A catalogue record for this book is available from
the British Library

ISBN 978 1 84976 036 2

Distributed in the United States and Canada by
ABRAMS, New York

Library of Congress Control Number applied for

Designed by Anne Odling-Smee, O-SB Design
Colour reproduction by DL Imaging Ltd, London
Printed and bound in Hong Kong by Printing
Express Ltd

Cover: Paul Klee, *They're Biting* 1920
(detail of fig.24)
Frontispiece: Paul Klee, *Young Lady's Adventure*
1922 (detail of fig.33)

Measurements of artworks are given in
centimetres, height before width

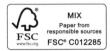

Photo credits

References are to figure numbers

akg-images 8
Bauhaus-Archiv Berlin 11
Robert Bayer, Basel 57
bpk | Bayerische
 Staatsgemäldesammlungen 30
bpk | Hamburger Kunsthalle | Elke
 Walford 38
bpk | Sprengel Museum Hannover |
 Michael Herling | Aline Gwose 19
Centre Pompidou, MNAM-CCI,
 Dist. RMN-Grand Palais / Philippe
 Migeat 34
The Israel Museum, Jerusalem by
 Elie Posner 25
Nina Kandinsky 10
Felix Klee 12
Kunstmuseum Basel. On
 permanent loan from the
 Emanuel Hoffman Foundation 48
Kunstmuseum Basel, Martin P.
 Bühler 37, 48
Kunstmuseum Winterthur, Dr
 Emil und Clara Friedrich-Jezler
 bequest, 1973 © Schweizerisches
 Institut für Kunstwissenschaft,
 Zürich, Philipp Hitz 51
2013 Kunsthaus Zürich. All rights
 reserved 46
August Macke 6
Fee Meisel 16
2013. Images copyright The
 Metropolitan Museum of Art /
 Art Resource / Scala, Florence
 © 2013. Images copyright The
 Metropolitan Museum of Art / Art
 Resource / Scala, Florence 35,
 47, 59
Museum Folkwang Essen 50
2013. Digital image, The Museum
 of Modern Art, New York / Scala,
 Florence 31, 39, 40, 41
Petra Petitpierre 14
The Pierpont Morgan Library, New
 York. Thaw Collection 28
Karl Schmoll von Eisenwerth 2
Foto: Staatsgalerie Stuttgart 32
Tate. Lent from a private collection
 2011 42
Tate. Purchased 1946 29, 33
Tate. Purchased 1964 53
Tate Photography,
 2013 frontispiece, 24, 29, 33, 42,
 53, 55, 56

L Tiedemann 1
Zentrum Paul Klee, Bern.
 Schenkung Familie Klee 1, 2, 4, 7,
 9, 10, 15, 17

Copyright credits

Joseph Albers © The Joseph and
 Annie Albers Foundation/VG
 Bild-Kunst, Bonn and DACS,
 London 2013
Wassily Kandinsky © ADGAP, Paris
 and DACS, London 2013